500
Tattoo
Designs

500
Tattoo
Designs

Henry Ferguson

THUNDER BAY
P · R · E · S · S
San Diego, California

Thunder Bay Press

An imprint of the Advantage Publishers Group

THUNDER BAY 5880 Oberlin Drive, San Diego, CA 92121-4794

P·R·E·S·S www.thunderbaybooks.com

Copyright © Collins & Brown an imprint of Anova Books Company Ltd, 2004

All notations of errors or omissions should be addressed to Thunder Bay Press, Editorial Department, at the above address. All other correspondence (author inquiries, permissions) concerning the content of this book should be addressed to Collins & Brown, 10 Southcombe Street, London W14 0RA.

ISBN-13: 978-1-59223-139-3
ISBN-10: 1-59223-139-X

Library of Congress Cataloging-in-Publication Data

Ferguson, Henry.
 500 tattoo designs / Henry Ferguson.
 p. cm.
ISBN 1-59223-139-X
 1. Tattooing—Catalogs. 2. Tattooing—Themes, motives. 3. Stencils and stencil cutting—Catalogs. I. Title: Five hundred tattoo designs. II. Title.

GT2345.F46 2004
391.6'5—dc22

2004040740

Printed in Singapore
4 5 6 7 8 11 10 09 08 07

Designed by Hardlines, Charlbury, Oxford, UK
Reproduction by Classicscan, Singapore
Printed and bound by Craft Print International Ltd, Singapore

Contents

INTRODUCTION

During the last decade or so, tattooing has become so popular that it is hard to believe that for many years, and in many societies, it was considered to be completely unacceptable—the prerogative of sailors, criminals, and those outside the bounds of respectable society. Yet tattooing is one of the oldest arts practiced by mankind, and it is found all over the world.

The 5,300-year-old Ice Man, whose frozen body was found in the Alps, was decorated with fifty-seven separate abstract tattoos. Embalmed Egyptian bodies from around 4,000 years ago had also been tattooed with designs of dots and dashes, and these were very similar to those found in neighboring Nubia. Later examples of Egyptian tattooing include images of the goddess Bes. The earliest examples of tattooed images of animals were found in the mountains of southern Siberia on the frozen body of a warrior chieftain. The man's shoulders, chest, and back were extensively tattooed with beautiful illustrations of fish and animals, including deer and members of the cat family—animals that also adorned much of the embalmed body of a high-status young woman from the same period who was found in the same area.

Only very unusual circumstances enabled the skin and flesh of these bodies to be preserved well enough for us to establish that they were tattooed, but we also know from contemporary writings that most European Iron Age tribes were decorated with tattoos of animals. Throughout the rest of the world, tattooing has traditionally

been widespread and today still continues to be handed down from generation to generation, for example in Malaysia, Nepal, Egypt, Thailand, and elsewhere. Polynesians are taking pride in rediscovering the beauty of their traditional abstract patterns. Japan has given us exquisite images, which can take years to complete. And in the West we are starting to appreciate the classic designs of roses, ships, eagles, hearts, and daggers, which represent the folk art traditions of our own tattoo heritage.

The desire to permanently decorate our skin is a very deep and ancient human urge, so perhaps the greatest puzzle is why do some of us choose to be tattooed while others do not? An old tattooist once said to me, with a wry smile, "Be patient. Wait. When it is your time to get tattooed, your tattoo god will speak to you." He was joking (I think) but I knew what he meant. Many people believe that tattoos have magical powers, and even those who don't believe in magic cannot deny that something very interesting happens during the process of tattooing, something that is more than mere skin illustration.

The fact that you are reading these words shows that your tattoo god is at least whispering quietly in your ear. This book will provide you with excellent information on the subject of getting a tattoo, in addition to being packed with a wealth of images through which you can browse, consider, and finally chose one (or more) to reflect who you are and who you wish to be. Choose wisely—you will never be the same again!

Henry Ferguson

Do It

Remember—tattoos last forever! Beware of getting a tattoo on the spur of the moment under the influence of alcohol, drugs, or any other stimulant. You should never arrive for the first time at a studio and get your first tattoo without checking everything out beforehand. There are different rules and regulations in different areas of the world, so you should take this into account. Tattoo parlors in Third World countries may not use up-to-date equipment, and it is worth noting that several places in the United States have outlawed tattooing, although these laws are constantly changing and it is worth finding out before you go there. In some areas minors cannot be tattooed without parental consent. As a first step, it is wise to check out the local laws.

Choosing a studio

Make a preliminary visit to several different parlors, and if possible ask for a tour before selecting which one to use. Remember that cleanliness is vital, so be very discerning when looking around. Ask to see examples of the artist's work—not just the designs used most often, but also photographs of finished tattoos. Check to see if the parlor is registered with a professional organization—membership is not obligatory, but will probably mean the artist is more up to date on industry standards and safety issues. For a list of reputable tattoo studios, check out the Alliance of Professional Tattooists (see page 256), a nonprofit educational organization that works to establish health standards within the industry. You could also look at one of the information sites on the Internet (see page 256).

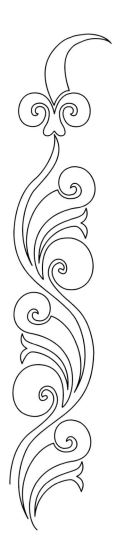

Health risks

Any time that the skin is pierced there are health risks. This includes being tattooed. You therefore need to be aware of what can go wrong. There is little risk of picking up any infection if all the equipment is properly sterilized. If not, you are most likely to contract one of the blood-borne infections such as Hepatitis B, Hepatitis C, or HIV/AIDS. You can protect yourself from Hepatitis B by being vaccinated at least six months beforehand, but there are no vaccines against Hepatitis C or AIDS.

Hepatitis B is a potentially serious infection and quite a few people who have Hepatitis B are not aware of it, as they have no symptoms. Around a quarter of those infected will develop acute hepatitis, of which maybe 10 percent will become carriers who can affect others. They may go on to develop liver disease, and a few will die. Hepatitis B is highly infectious and can be passed in only tiny amounts of blood, so it is very possible to catch it from an infected needle—there is around a 20 percent chance. The virus is very hard to kill and can survive indefinitely outside the body. To eradicate it, instruments must be heated to 250°F for at least thirty minutes in an autoclave.

By contrast, the chances of getting HIV from a contaminated needle are one in 200, because to transmit the disease at least 0.1 ml of blood needs to be passed from an infected source. In tattooing, there is no blood in the needle, so a significant amount of blood cannot be passed across. The HIV virus will not survive for more than a couple of days outside the body, and it can be killed externally with boiling water and a number of disinfectants.

The only acceptable method of sterilizing instruments is an autoclave, which is a steam, heat, and pressure unit used in hospitals. Instruments are placed in special pouches to go into the machine, and indicator strips change color when the sterilization process is complete.

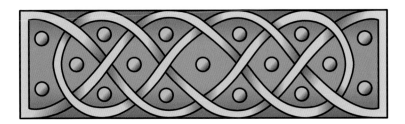

Apart from infections, there are a few other potential problems to consider, including a possible allergic reaction to the ink. If you have had a bad allergic reaction to any substance in the past, it would be wise to have a small patch test in an inconspicuous place. For some reason there have been several cases where skin has reacted only to the red section of a colored tattoo—often some years after the tattoo was done. Although it was at first thought that this was due to a sensitivity to specific ingredients, reports have continued with a range of different red pigments. Mild cases can be treated with ointments; more severe instances need treatment by a dermatologist.

There have been some reports of existing skin conditions, such as psoriasis, being aggravated by tattooing, so if you are prone to any such problem, proceed with some caution. Most tattoos heal well, but there have also been instances of keloid scarring, in which a hard lump of scar tissue develops where the skin has been damaged, making it look lumpy and restricting its elasticity. Keloid scarring can be removed surgically, but this will almost certainly also both destroy the tattoo and leave an unsightly scar. Developing such a problem is more likely if you have had keloid scarring on injuries in the past.

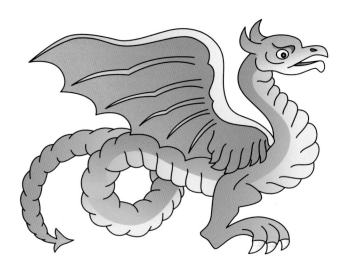

What to expect

The tattoo artist should be working in a clean and disinfected area, and should wear disposable protective gloves. The autoclave-sterilized equipment should be opened in front of the client and all the inks to be used in the design should have been decanted into single-use cups. The area of skin to be tattooed is shaved and disinfected, and then the outline of the design is drawn onto the skin. Using a single needle in the tattoo machine, the artist begins to mark the outline—usually in black ink. An expert tattooist will be able to create a clear line without going too deep—not going deep enough gives a scratchy-looking line; going too deep causes excessive pain. When the outline is completed, shading and special effects are usually added with a combination of needles. After the skin has been cleaned again, color can be introduced. To create even blocks of color, the artist needs to overlap the lines. Usually there is little bleeding, and what bleeding there is stops a few minutes after work has been completed.

Health and safety rules

- Check that the instruments are stored in an autoclave and that its certificate is up-to-date.

- Make sure that all instruments are carefully sterilized between clients.

- Check the artist's certificates. These should certainly be on display.

- Make sure the artist wears disposable protective gloves when working.

- Ask if the artist has been vaccinated against Hepatitis B.

- Check that all inks are poured into a separate container for each client, and that unused inks are disposed of and not reused.

- Make sure that the needle is taken from the autoclave in front of you, and that it is correctly disposed of in a needle-proof container afterward, before being incinerated.

- Don't forget any water and ointments that may be used—these should also come from separate containers and be decanted into smaller ones for each client.

- Never drink alcohol before going for your tattoo—you may need Dutch courage, but alcohol in the bloodstream can cause excess bleeding.

Flaunt It

Although you can have a tattoo more or less anywhere on the body, some designs seem to lend themselves more readily to specific places. The tattoo designs featured in this book are in many cases quite general and can be placed anywhere you choose. The final positioning should be decided by you and your chosen artist.

Does it hurt?

The simple answer is yes! But how much it hurts depends on the skill of the artist and on your individual pain threshold. The sensation has been described as tingling, like pinpricks, comparable to a bee sting, and like a drill piercing the skin.

When you are selecting your design, you should not only consider its appeal, but also where you are going to place it. Some areas of the body are much more sensitive than others, and going for a large and complicated design will probably mean submitting to several quite painful sessions as the artwork is built up. It may be better to start with something small and simple to see how you like it. Parts of the body where the bone is near the surface tend to be more sensitive than where there is a good layer of tissue to cushion the skin. To help you decide, consult the "pain index," in which one is most sensitive and seven is least sensitive.

Pain index

Genitals	1
Sternum and ribs	2
Hands and feet	3
Head	3
Ankles	3
Groin	4
Under arm	4
Lower back and neck	5
Calves and outer thighs	5
Shoulder blades	5
Upper arms and forearms	6
Bottom	7

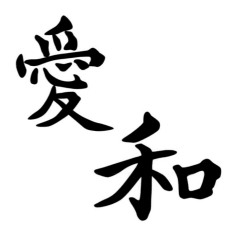

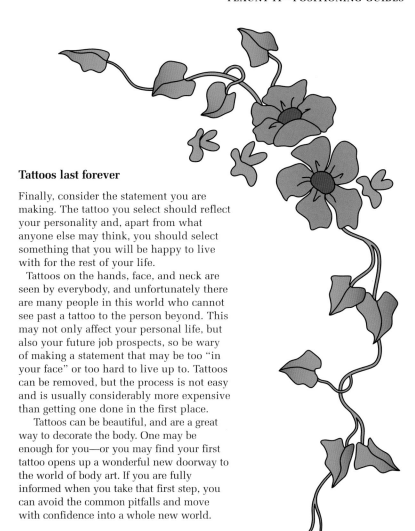

Tattoos last forever

Finally, consider the statement you are making. The tattoo you select should reflect your personality and, apart from what anyone else may think, you should select something that you will be happy to live with for the rest of your life.

Tattoos on the hands, face, and neck are seen by everybody, and unfortunately there are many people in this world who cannot see past a tattoo to the person beyond. This may not only affect your personal life, but also your future job prospects, so be wary of making a statement that may be too "in your face" or too hard to live up to. Tattoos can be removed, but the process is not easy and is usually considerably more expensive than getting one done in the first place.

Tattoos can be beautiful, and are a great way to decorate the body. One may be enough for you—or you may find your first tattoo opens up a wonderful new doorway to the world of body art. If you are fully informed when you take that first step, you can avoid the common pitfalls and move with confidence into a whole new world.

Body Art in Color

Deciding on a design

It is important to remember that a tattoo is a long-term statement, so try not to pick a design that may go out of style too quickly. No one can see into the future with 100 percent accuracy, so be wary of going for something too offensive—in a few years you may feel differently about how you want to present yourself to the world. Although tattoos can be removed, it is uncomfortable and expensive! Regard your tattoo as a permanent investment in yourself.

The size and color of your tattoo will make a big difference on how it looks when it is done. Discuss your plans with your tattoo artist—he or she is the expert and will know how the final design will turn out.

Using color

Adding color to your tattoo can change the look of the design quite dramatically. Some designs are not suitable for coloring, so if you want something multicolored, be sure to pick artwork with areas where color can be introduced. Representational designs such as butterflies, flowers, and dragons are ideal for color, while geometric designs, lettering, and designs relying on shading are less so. When choosing your colors, remember that areas that are white in the tattoo design will be skin tone colored when they are on your skin.

Aftercare

You will need to take care of your new tattoo properly if it is to end up looking its best. Within two hours, remove the bandage and do not re-cover the area—it needs fresh air to heal properly. Wash your hands, and then gently wash the tattooed area with warm, soapy water, preferably using a gentle, antibacterial soap. Rinse with cool water, but try not to soak the area too much. Pat dry gently with a soft towel or absorbent paper towel—don't rub it or you will damage the skin and perhaps also destroy the design.

For the next few days, until the tattoo has healed, apply a thin coat of a suitable ointment containing vitamins A and D, which will promote healing, or use a very mild antiseptic or zinc oxide cream. Apply the ointment at least

three times a day, after gently washing the tattooed area as described before. Make sure the skin in this area does not dry out, but do not apply too much or it may pull the color out of the skin.

As it heals, the skin around your tattoo will begin to flake. Resist all temptation to pull the flakes off, as this may also remove patches of the color. If your tattoo is in an area normally covered by clothing, wear loose garments and do not let them rub against the tattoo until the area is fully healed. Avoid swimming or sunbathing for the time being. You can apply an ice pack if swelling or redness occurs, but if there is any sign of infection consult a doctor. Within seven to ten days your tattoo should be fully healed and revealed in all its glory. When out in the sun from now on, remember to apply a high-factor sunscreen to the tattooed area to prevent the colors from fading.

Tattoo removal

Around 50 percent of people who get a tattoo will want it removed later in life, which is a complicated business and much more expensive than getting one done in the first place. It also carries the same health risks, so ensure that removal is done by a qualified medical professional. The success of removal depends on several factors, including size, location, the individual's healing process, how the tattoo was applied, and the length of time it has been on the skin. A tattoo performed by a more experienced tattoo artist may be easier to remove, since the pigment is evenly injected to the same level in the skin. A tattoo that has been on the skin for a considerable length of time may be more difficult to remove than a new one.

There are several ways in which tattoos can be removed, including excision, in which the tattoo is removed surgically, and dermabrasion, in which the tattoo is sprayed with a freezing solution and then "sanded" with a rotary abrasive instrument, causing the skin to peel. However, one of the best modern methods of removal is by laser, in which a cream to numb the skin is applied, and then pulses of light are directed onto the tattoo to break up the pigment. Over the next weeks the body's scavenger cells remove the pigment residues. More than one treatment is usually necessary for an average-size tattoo, and at least three weeks must be left between each session. Black is the easiest color to remove, because it absorbs light well. After the session, the skin may be red as if it is sunburned, and a scab may develop, but after healing the tattoo color will gradually fade. However, in most cases some scarring or color variations in the skin tone will remain.

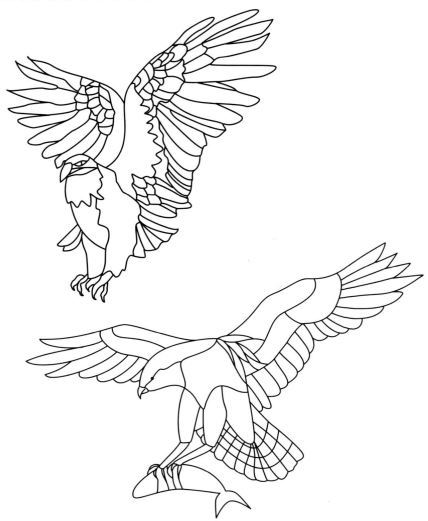

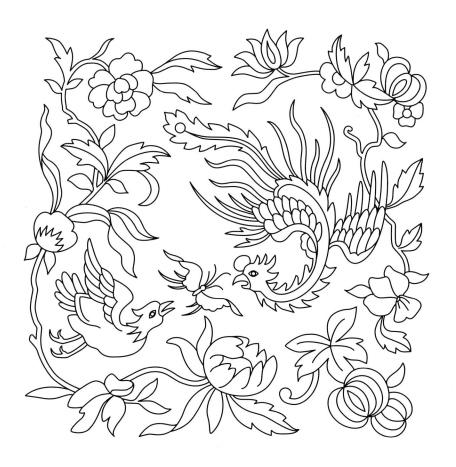

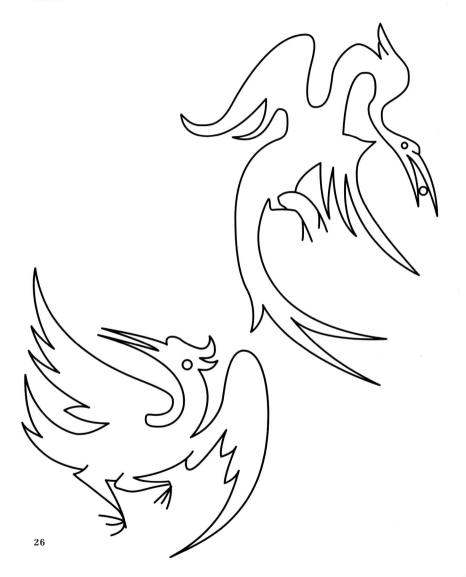

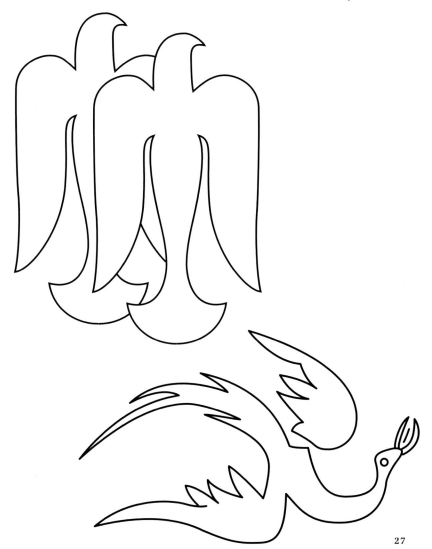

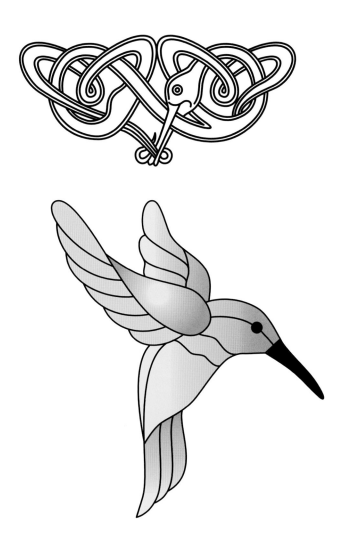

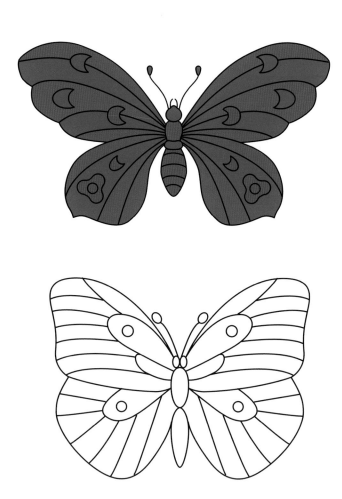

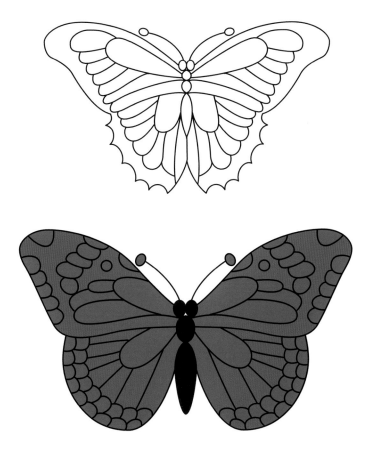

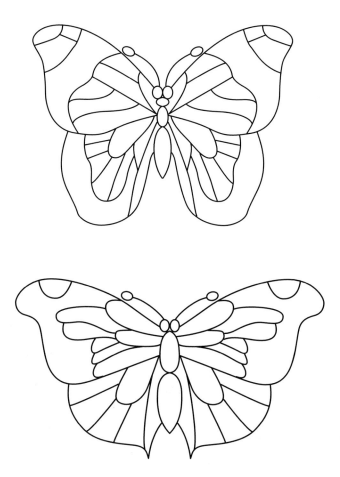

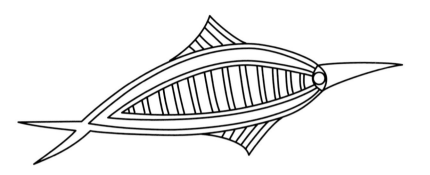

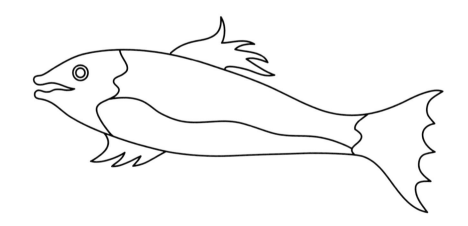

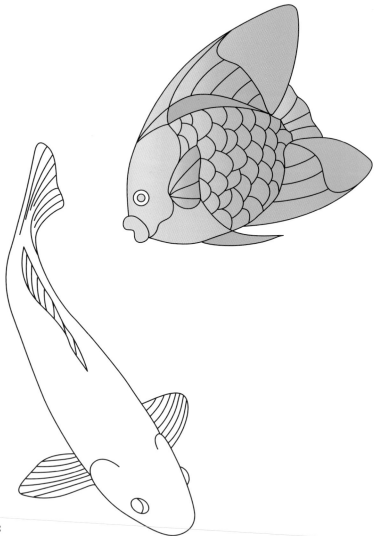

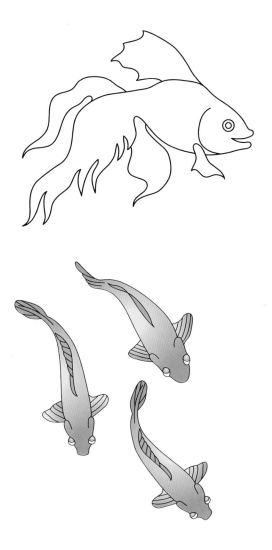

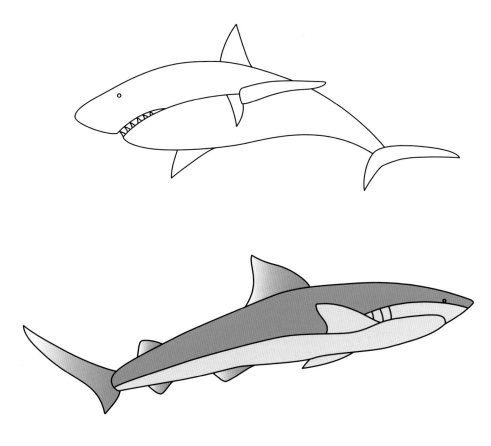

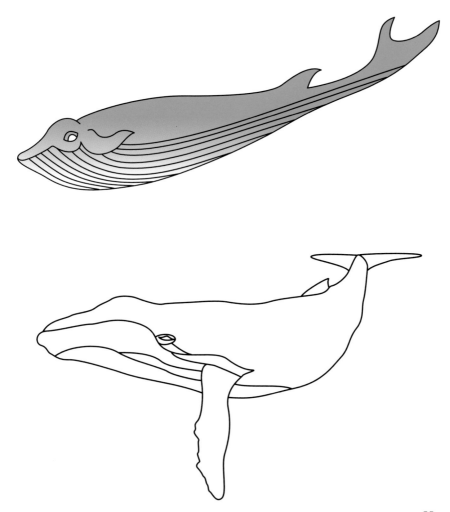

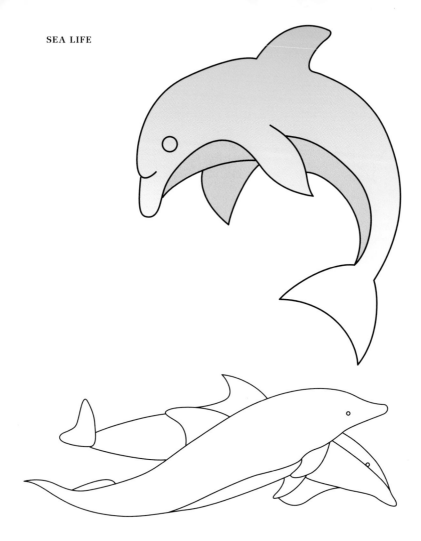

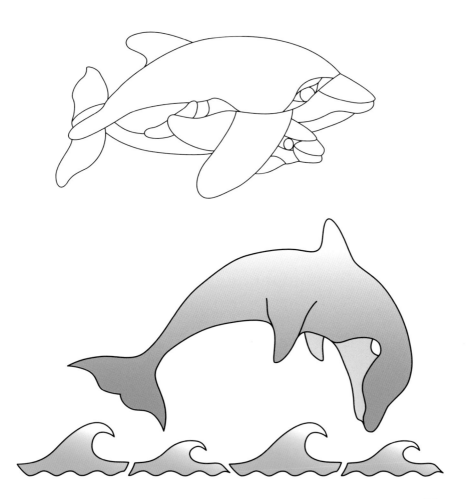

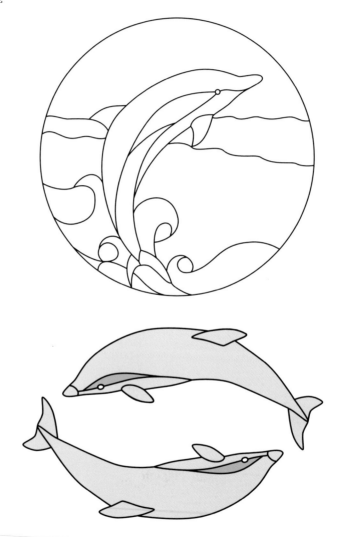

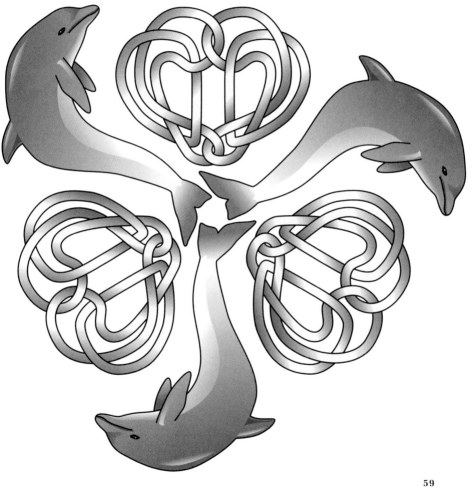

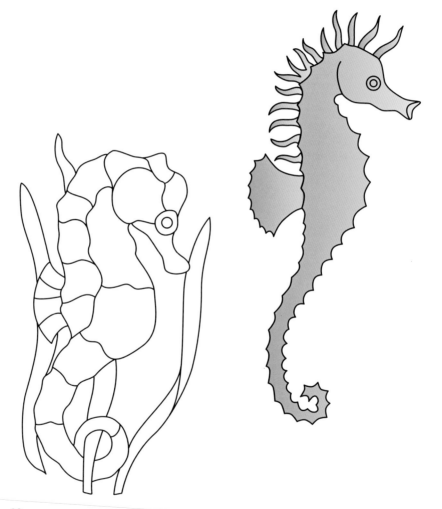

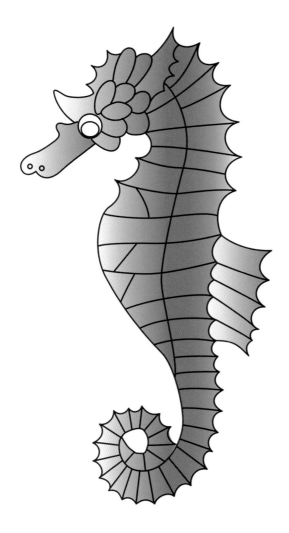

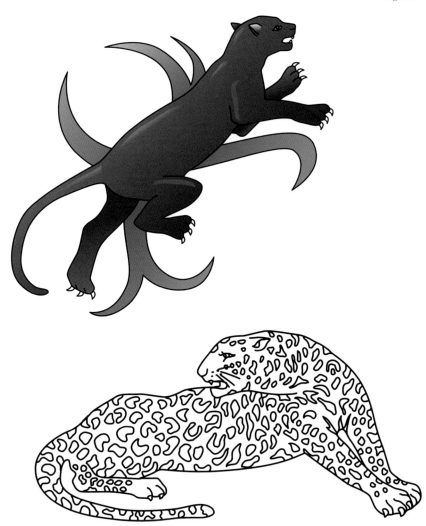

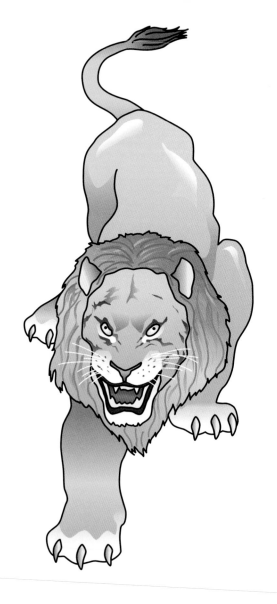

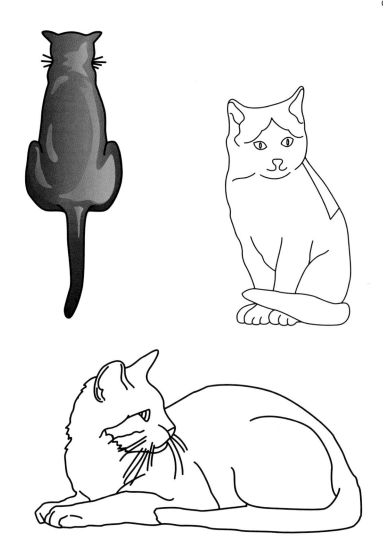

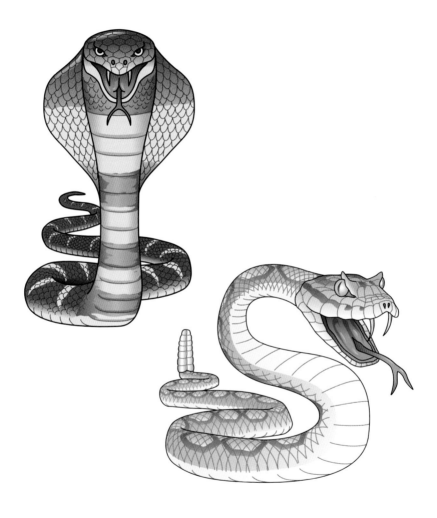

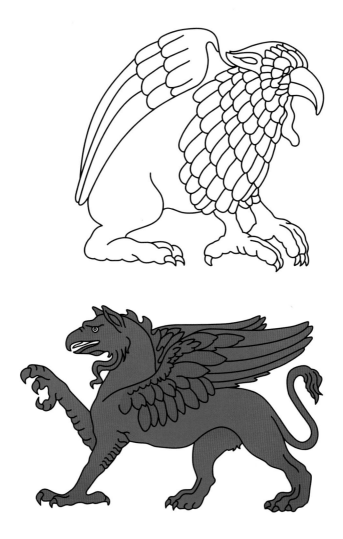

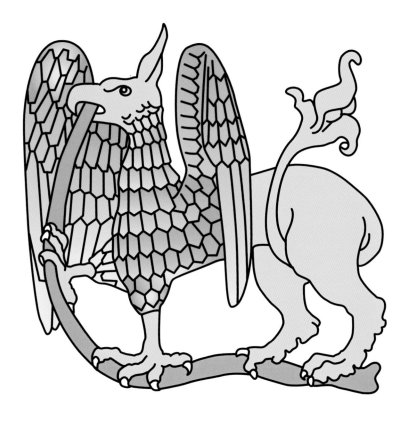

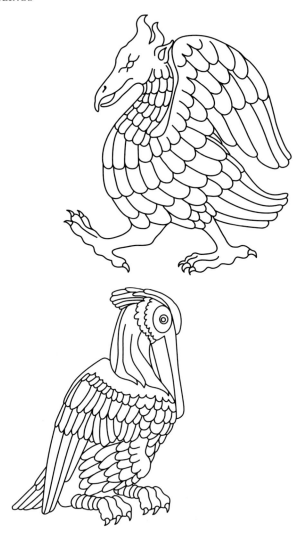

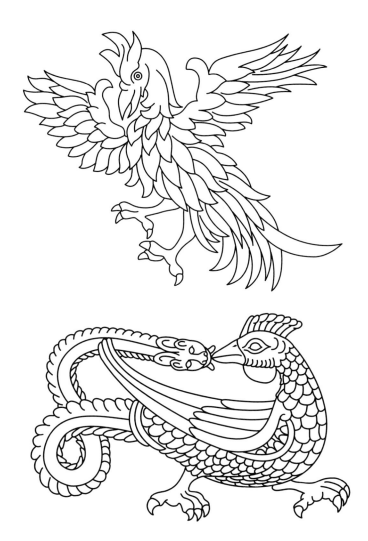

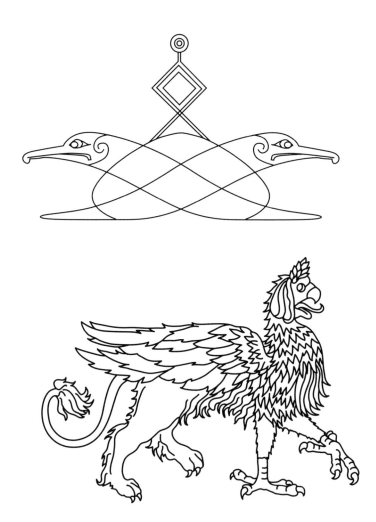

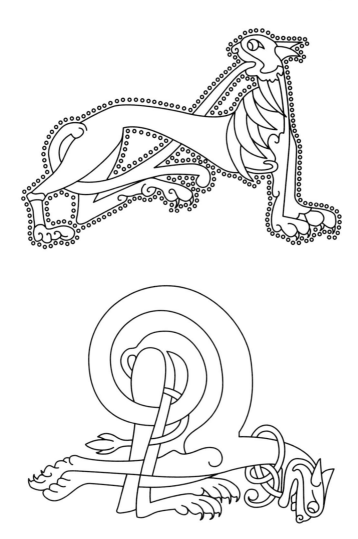

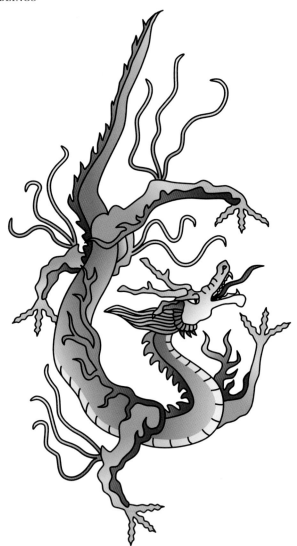

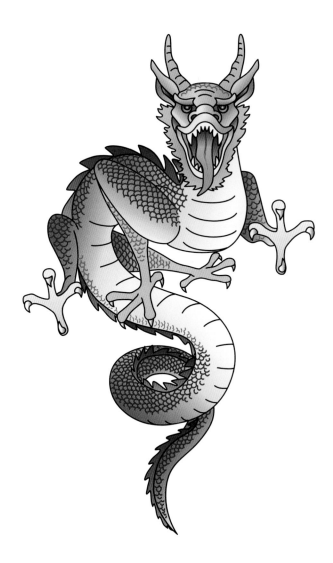

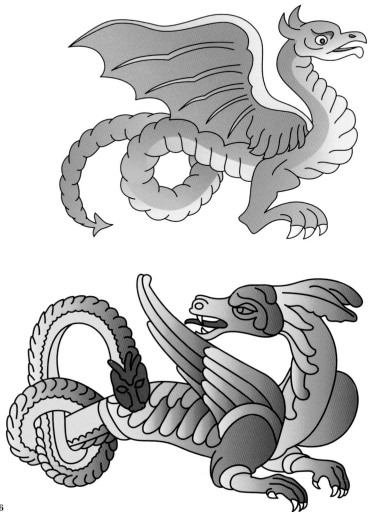

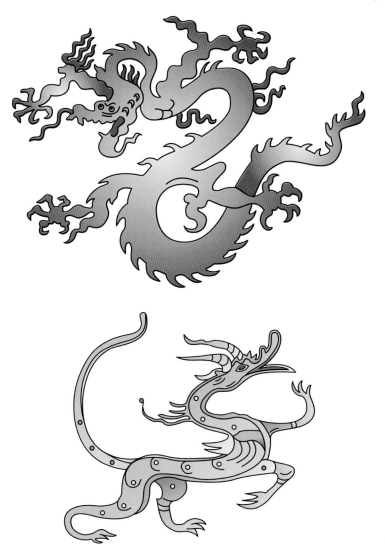

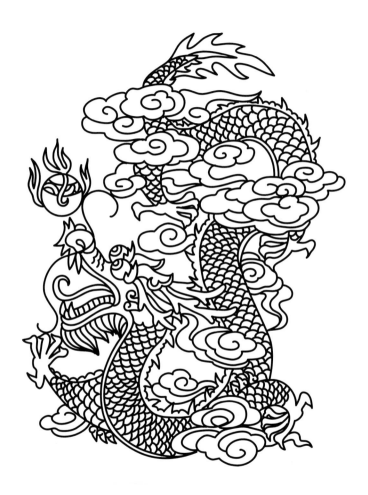

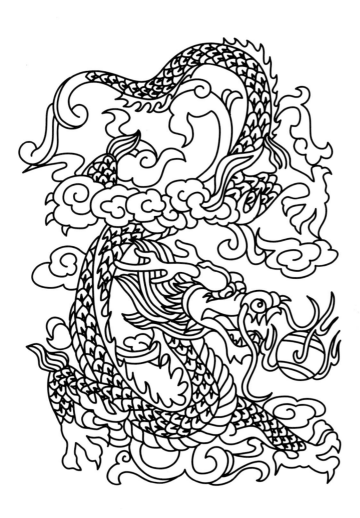

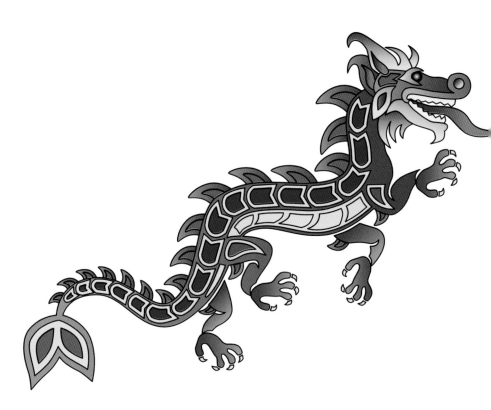

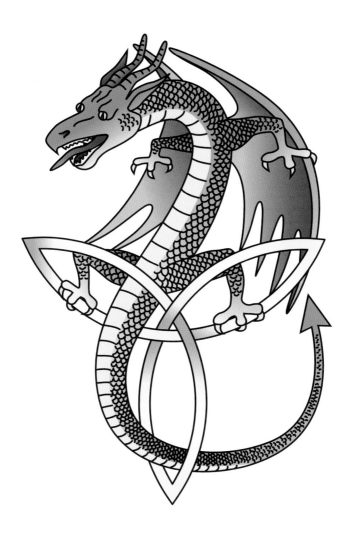

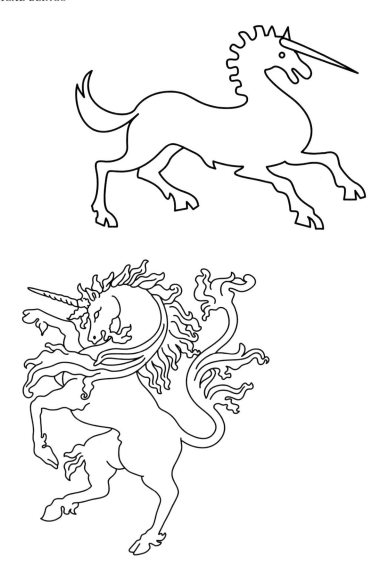

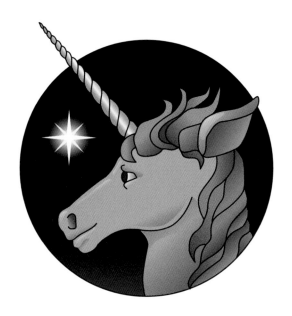

FLOWERS AND FOLIAGE

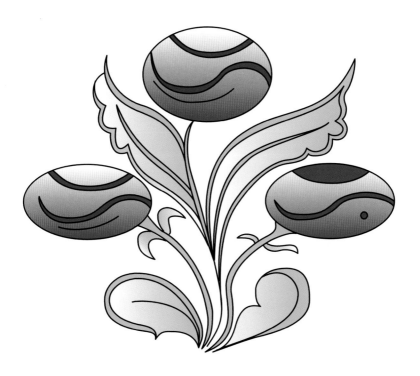

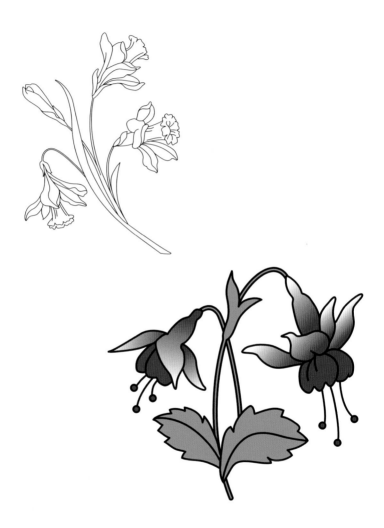

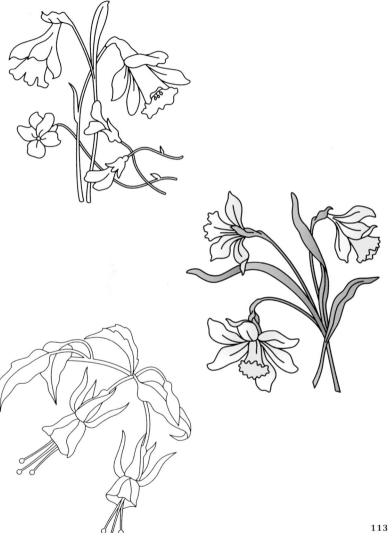

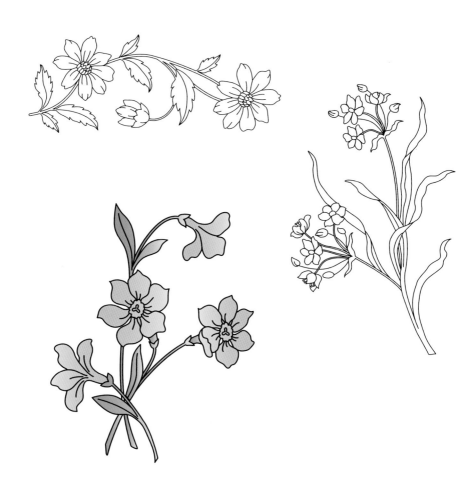

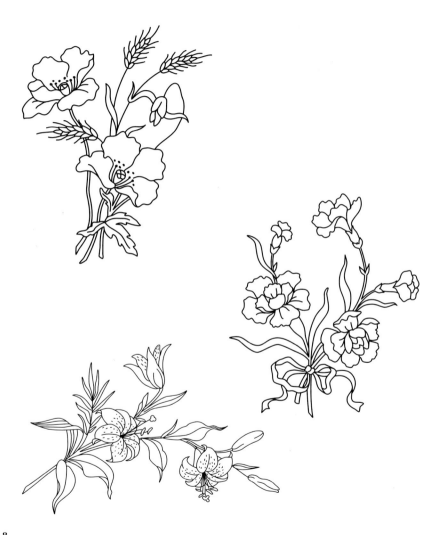

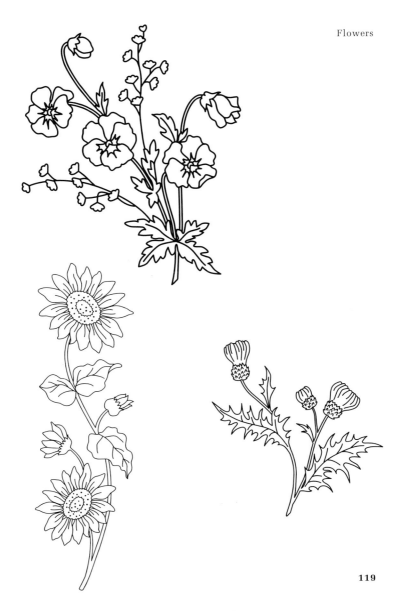

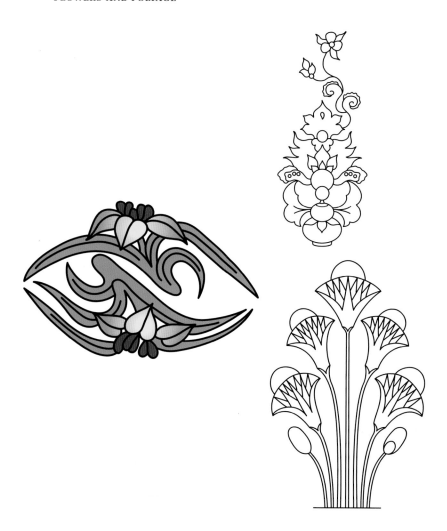

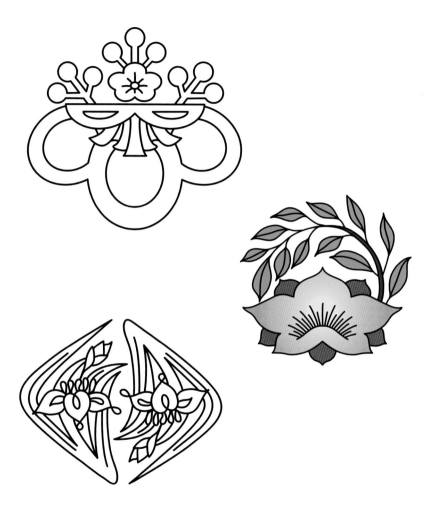

CULTURES

150

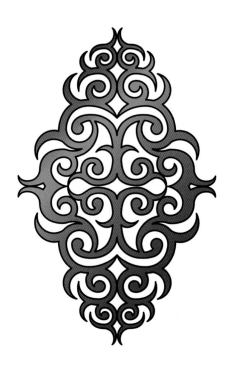

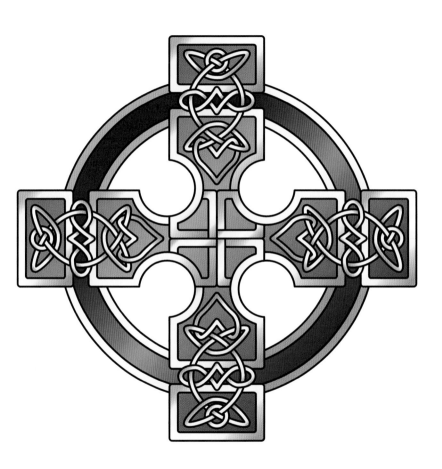

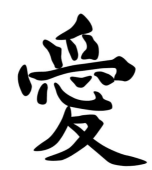

Love

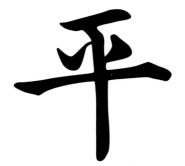

Peace

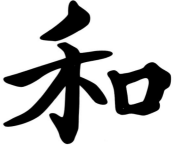

Harmony

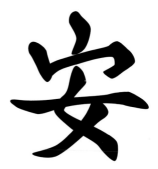

Tranquility

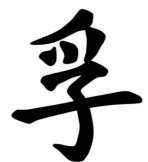

Truth

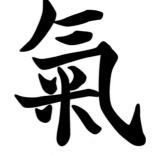

Energy

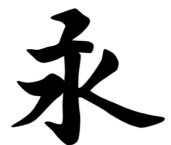

Eternity

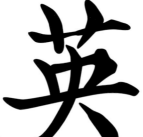

Courage

Honor

Strength

Prosperity

Wellbeing

Happiness

Beautiful

壽

Long Life

喜

Joy

興

Rejoice

Chinese

Dragon

Mountain

Tiger

**181**

 Cat

 Heart

 Gold

Light

Sun

Bird

Heaven

Earth

Wind

火

Fire

水

Water

花

Flower

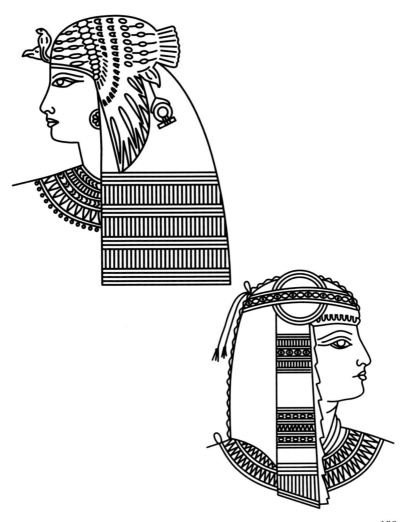

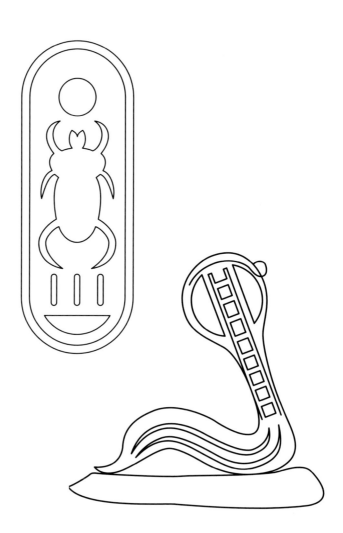

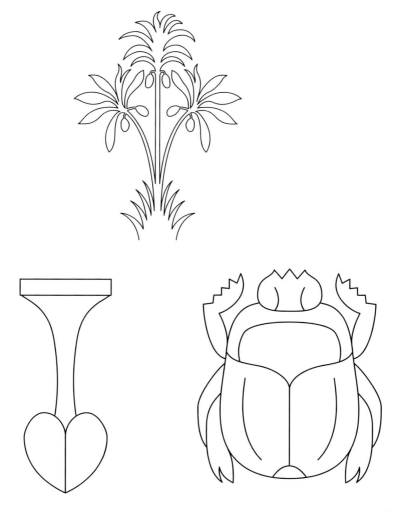

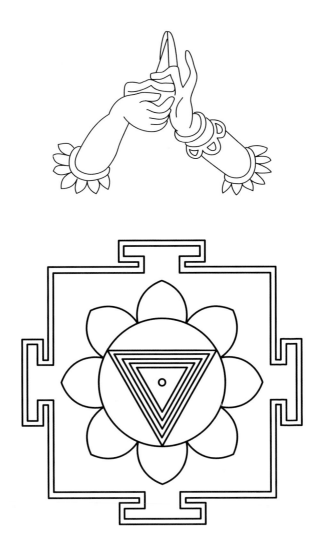

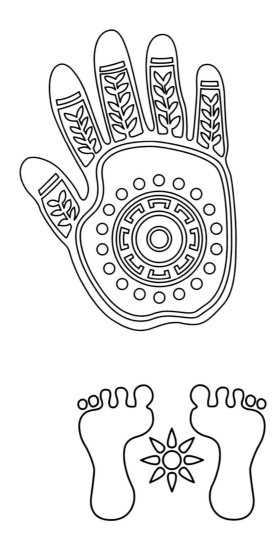

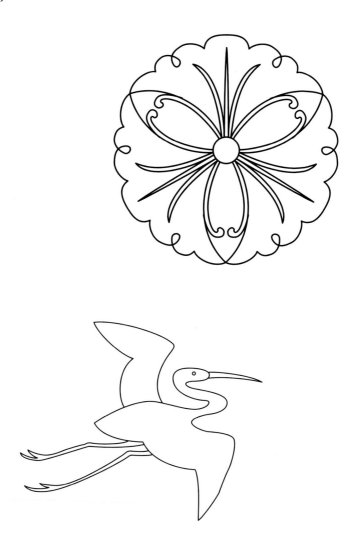

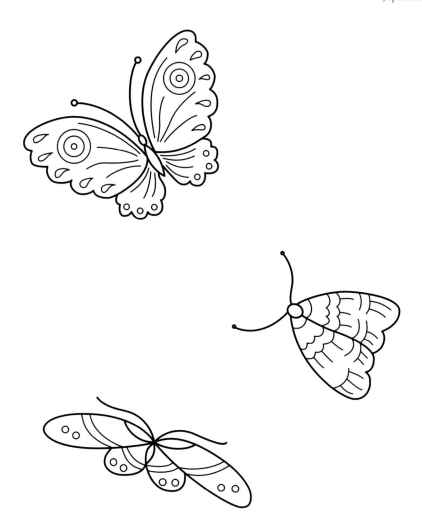

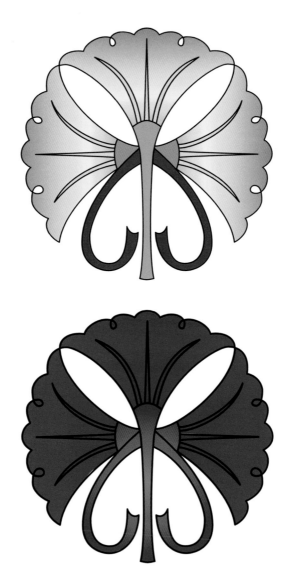

Symbols Symbols

Capricorn

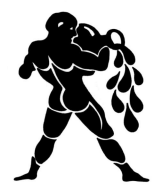

Aquarius

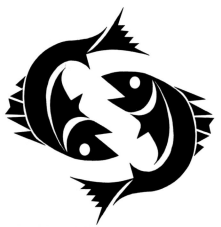

Pisces

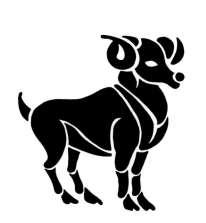

Aries

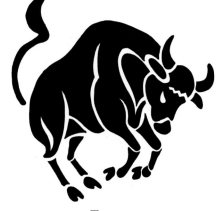

Taurus

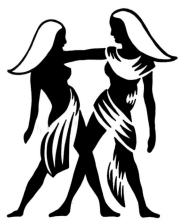

Gemini

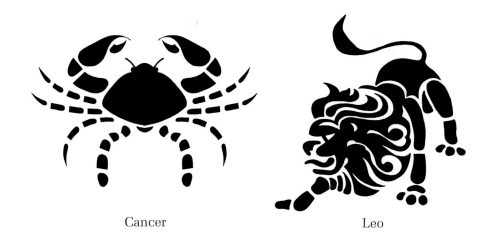

Cancer

Leo

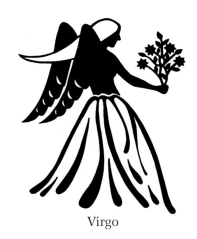

Virgo

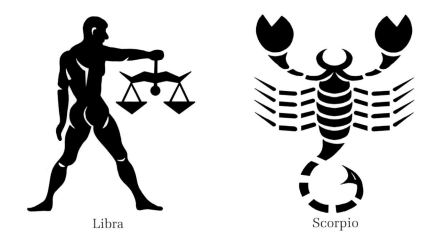

Libra

Scorpio

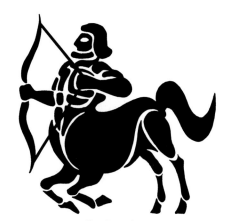

Sagittarius

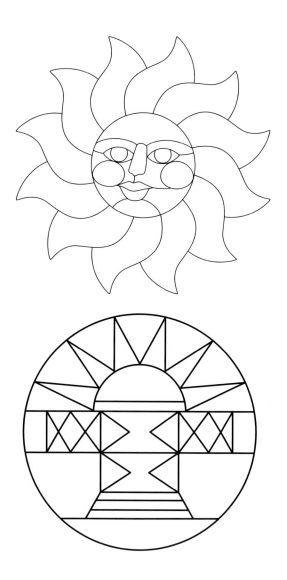

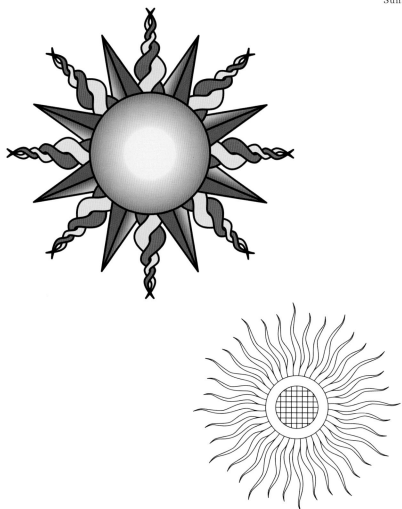

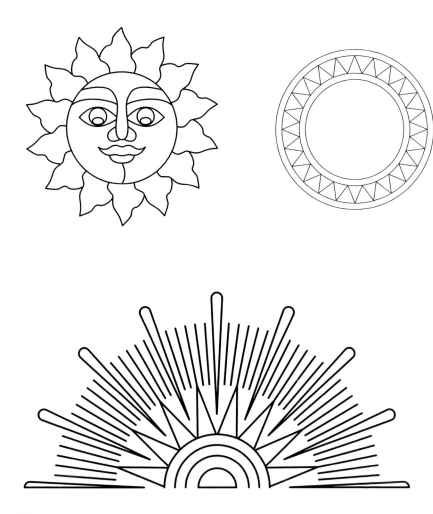

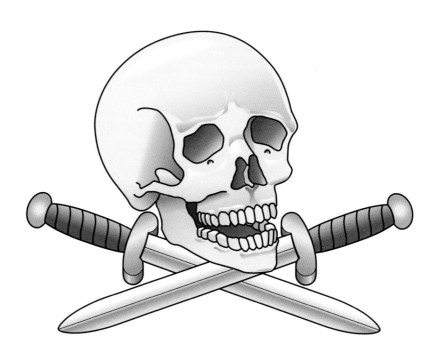

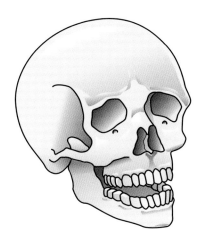

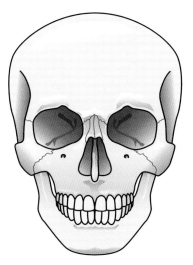

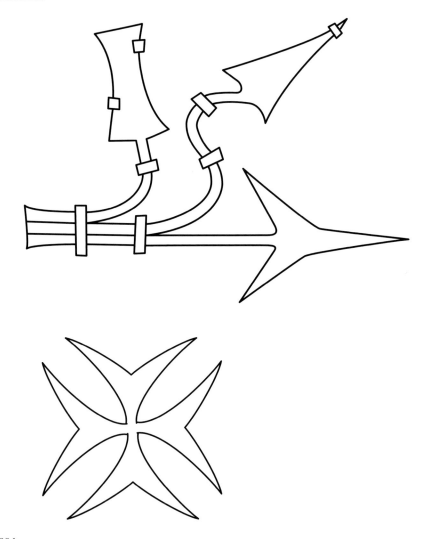

253

RESOURCES

Alliance of Professional Tattooists

A nonprofit educational organization that teaches tattooists and consumers about the prevention of disease transmission in tattooing.

www.safe-tattoos.com

National Tattoo Association

A nonprofit educational organization dedicated to raising social consciousness of tattooing as a contemporary art from.

www.nationaltattooassociation.com

SkinArt.com

Tattoo art by award-winning international artists.

www.skinart.com

The Tattoo Club of Great Britain

This organization can be contacted for certain rare and limited edition books at 389 Cowley Road, Oxford, OX4 2BS, UK.

www.tcgb@tattoo.co.uk